ABSTRACT: *Independent AF Edition.*

This is a work of fiction. Any names or characters, businesses or places, events or incidents, are fictitious. Any resemblance to actual persons, living or dead, or actual events is purely coincidental in both written and visual form.

ABSTRACT

A Collection of Art and Poetry
Illustrating the Human Experience.

BY

Alex Freund

For those who need to feel heard,
but are afraid to speak.
-AF

CONTENTS

Introduction

If you are reading this, I presume one of two things are true; you have impeccable taste in art, or you don't.

ABSTRACT contains a group of writings I wrote throughout my 20s, journaling my thoughts as I processed grief, a global pandemic, and in a more general sense, my mental health and identity. The narratives are a deeply personal expression of an inner monologue during a period in my life I am proud of navigating and surviving.

The paintings and illustrations included were created over the same ten-year span as my writings; from age 20 to 30. Art was, and continues to be, a release of emotions in a times I don't know how to sit in my emotions. A lot of the colors and textures found in my abstract works were influenced by the music I listened to as I painted.

Act I includes narratives and art I created in my early and mid twenties during a period I felt uncertain in my path. Consistently confused about who I truly was as a person, and ultimately grieving in every sense of the word. Grieving who I thought I was going to be, grieving my childhood, grieving loss of loved ones. I recall a daily battle for anything positive.

Before Act II, I have included an optional intermission for those who would like to skip reading about topics related to covid, religion, sex, and clowns.

Act II is a collection of abstracts and illustrations I used as an outlet to release emotions due to my inability to process and sit in what I was feeling.

The final act of this book feels like a drastic contrast to the rest of the content covered. As I began my therapy journey and really took note of what I wanted in life, my identity and my mental health started to become clearer and my ability to focus on the present while being intentional with what I surround myself with began to take shape.

To those that my art resonates on any level, I am sending you positivity.

Act I:
Searching for Purpose

The Lot.

Day off. Time to kill. Rain coming down despite the 0% chance of precipitation viewed earlier.

Sitting in a vast concrete parking lot of a favorite retail store simply to admire the rain and thunder by myself.

While water pinging against the metal roof of my 2008 Chevy Aveo, I notice in my peripheral vision a handful of others doing the same.

Checkered equally amongst the stalls, 7 or 8 motorists take a breath and enjoy the clouds crying on the plains.

The gentle rumble of thunder awakens the crossover a few stalls down, reminding it that break time is over.

Late for a meeting that probably doesn't matter in the grand scheme of things.

Lastly, I see it, as the clouds begin to dissipate, the golden glow shines through the otherwise foggy haze.

Is this Mother Nature telling me everything will be alright?

Nope, just the Golden Arches telling me the McRib is back.

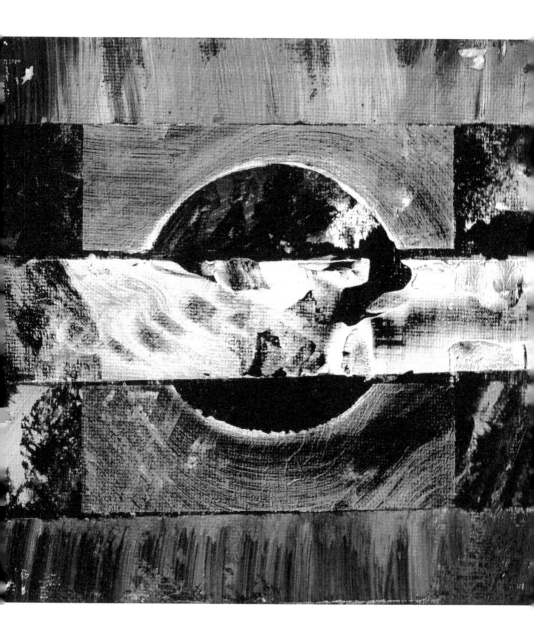

Balancing Pool Chemicals.

I feel that many people's problem with religion is that the main focus is what comes next. It seems to be hyper focused on death and the events afterwards.

Sign up now to be happy later. When is later?

We don't have the answers Sway.

What if when we die we replay our entire life in 7 minutes but it feels like eternity? What if that eternal 7 minutes is the holy trinity of Heaven, Hell, and Purgatory? What if we all are living our seven minutes worrying about the end when the end has already happened?

This isn't a cry for help. It's just something that has fluttered around my brain for a few minutes listening to what I thought was going to be a comedy podcast.

If we can harness the idea that we are living our 7 minutes knowing that what's done is done, then we can harness the ability to appreciate the current and follow what interests us without fear of what if because 'if' has already happened.

I think so many people can live this way...in spurts. They can relinquish nuggets of cliché knowledge to help out others, but fail many times to ingest their own advice. It's easier to say that it's a journey not a destination because a destination means there is a conclusion and that is, in many perspectives, tragic.

There is a great concept I heard once that said poetry and art is at its best when you omit elements to generate gray area that sparks imagination.

Much like that concept, that's how I will end...

Matter.

What's the matter?

No.

Who matters?

You do.

You matter to someone, to something.

To quote the great Chicago poet Chancellor Bennett:
"Everybody's Somebody's Everything.'"

Your bed needs you, otherwise it's just some soft textile and springs with no purpose.

The air needs you to convert oxygen into sweet, sweet Carbon Dioxide.

Your friends and family and pets need your company.

I need you to keep reading.

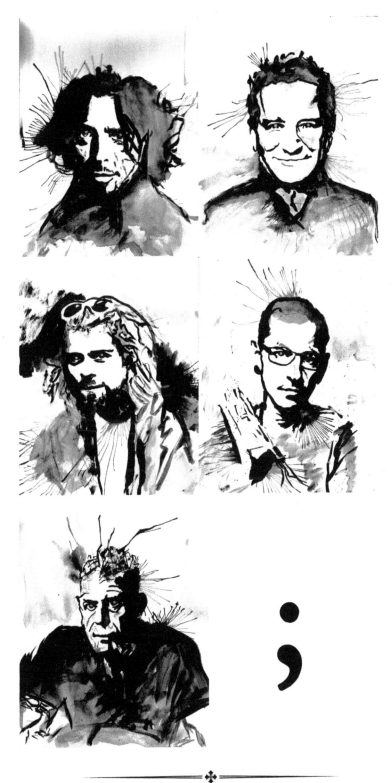

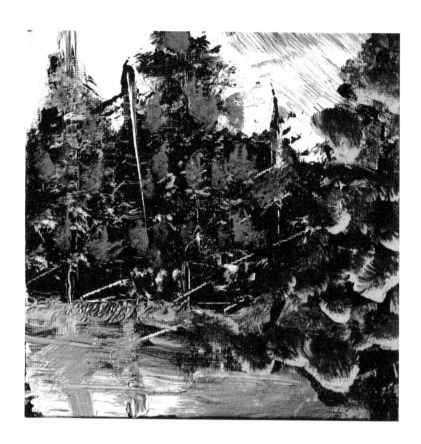

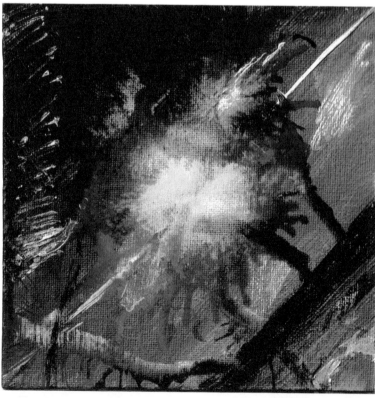

The 27 Club*

For 14 years I've had a looming feeling that I would perish early.

How young?

27.

Sometimes it was a fear, sometimes it was a wish, and other times it's just been a present consistent thought.

I would imagine who would come to my funeral and how long I would live in memories.

The fear of dying by 27 is closing in and I'm realizing it's not a fear of dying young, it's simply a fear of living past 27.

Definitive endings have always been one of my fortes and leaving something left to be desired is the other.

Twenty-Seven. What a perfect bow atop my accomplishments and potential.

I'm afraid midnight is going to come at the end of the 11th and I'm going to have my thoughts and my everything. I'm going to have to start living and figure out what that means.

I've packed a lifetime into 27 and I'm scared I'm going to lose it all someday.

I must figure out what drives me, what family truly means to me, what makes me fulfilled without the influence of everyone else and I have ALWAYS done one of two things: try to fit in so much it hurt or embrace being so different no one would want to connect with me.

*This feels unfinished, but I recall typing this as I turned 28 and wept and opted to just feel instead of intellectualizing.

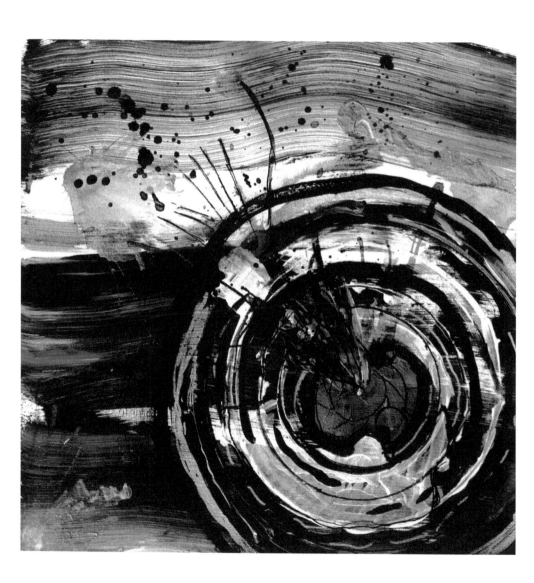

Presently Physical

What is it about a handwritten note that resonates on a different level? When you read the same thing on a machine it feels less. Less purposeful, less vibrant, less...

When I type 'if you need anything, let me know', do I mean it?

Can someone sense my sincerity? Do they believe it or question it?

Why do I turn my head slightly askew when I'm allowing my care drip out when I'm speaking?

If we don't post it, did it happen? If I don't talk about it, did it happen? If it lives digitally, does it exist?

If there isn't a tangible memento, is it even real?

There is a battle between my need for normal normalcy and my need to experience new experiences. It's a contradiction that only feels possible when juggling uncertainty and the self-imposed job of leading the charge. The focus on what comes next or how to get there, blinds, or at least blurs, what truly matters.

I'm here physically, you are too. You are reading this in the present but where am I? Am I in the future or caught planning it?

My biggest fear is I'm in the past and I can't escape it.

Those damn mementos.

Here's your present.

The Caddy.

He could have told me everything that was to happen between when the photo was taken and October 11th, 2018, but I don't think I would have believed him.

He could have said 'Alex, I'm going to live til 90 and it's going to be alright'. I would have responded but your dad lived til 93, why can't you stay 'til then?'

He would have kindly responded 'but I will speak at your wedding before then, it's okay'. My response would have sounded absurd, but I would have said 'but what about Taylor's wedding? Or Connor's, or Emily's?'

He would have said something brilliant like 'there's no rush for them, the timing isn't right, it will be right when those things happen, but I'll have to attend from afar. I can only physically see things one at a time now, but after October of 2018, I'll be there always; for everyone.'

Those are the things I imagine are being said in that photo, but odds are he was saying 'now we are going to pose for a picture... that will perfectly show how you will see me for years to come. It's important to have someone to look up to ya know?'

Or maybe something simpler like 'the nice thing about golf is there's always room for improvement and second shots.'

Of course, that's what I wanted to be told, but who can say for sure what was really said that day 20 years ago?

All I can say now is I miss you; I love you, and rest easy 'til I see you again, I'll be here.

✤

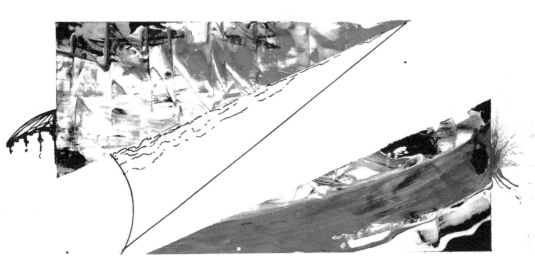

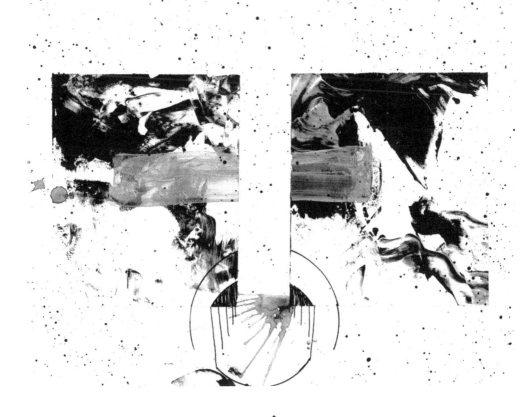

Ode to the Midwest.

The Bible Belt, the Bread Basket of America, or as I like to call it, God's Billiard Table.

Rolling up on a four way traffic stop, the two other vehicles wave me through despite arriving last to my location.

I watched a man awkwardly jog from his parking spot to the gas station door while losing his shoe in the lot during his quick stint of exercise. The sneaker met the underside of a motorcycle's tire which caused an unfortunate series of events to transpire, not only to the footwear but to the cycle and man atop of his steel horse.

Instead of a fight or a violent exchange of words, both parties apologized and went about their day.

After the sign from the Golden Arches a few days prior, I head into the closest establishment for some bargain nourishment.

Half expectedly, I see a patron holding his arm stretched straight with his fingers keeping the door ajar until I make it inside. Seeing his struggle to maintain the hold for much longer, I briskly walked faster to thank him swiftly before ordering a healthy meal of fried potatoes and chicken.

We are at the point in the seasons that the wind, which usually is shunned for most of the year, has a welcomed response from people making small talk. Instead of saying the temperature isn't that bad, it's just the wind...the opposite is in effect.

Thank the Lord for the wind today, otherwise I would rather be inside.

❖

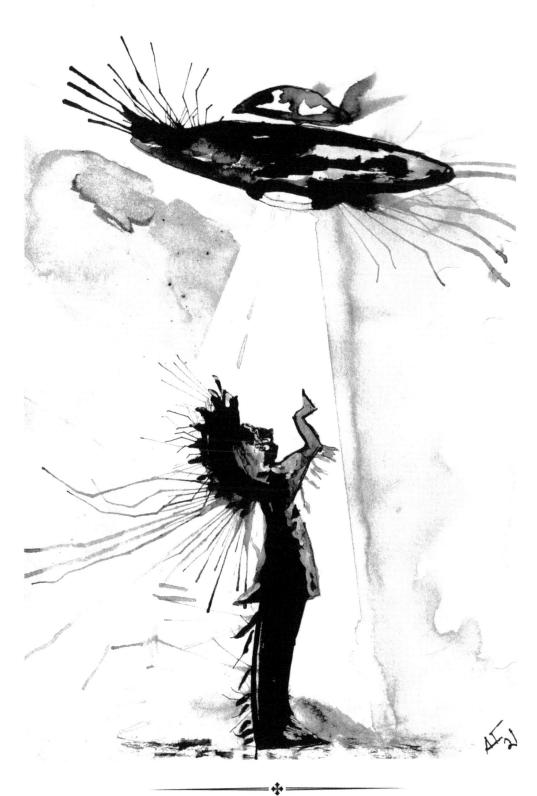

Redux.

Intentionally attentive attempting to live.

To live with an inner monologue that loathes more than loves; daring to spare change.

Purposeful presence for the power of present.

Current mindfulness for the waves that alter the tides and tied me to the current.

Influential misconnected memories mangled by the murky haze of trauma so powerful I invalidate my own emotions for a moment.

Fuck that.
I know better.

I know better, now…

Hard work, continual confrontation of fake facts, and manually intensive maintenance to make sure my mental state stays stable.

Reluctantly reflective and cautiously optimistic for now.

✦

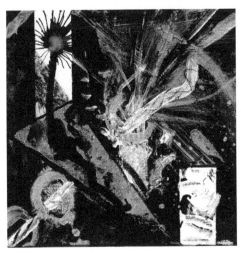

Exit Stage Left.

Guilt, the feeling I'm feeling.

I've never felt the way I feel right now; loving someone so much and knowing you need to let them go so that they can go home.

Being spiritually connected with music has made the past 3 weeks a whirlwind of emotion. A harmless song can be played in the distance and bring tears to my eyes faster than imaginable.

Age is just a number, just because a person is higher in age doesn't mean their departure is any easier.

Hurry up and wait.

Waiting.

Hurting.

Ready for the next phase, whatever that may be.

Ready for clarity.

Waiting for happiness.

I miss you already and it's okay to go home.

The trouble painting someone in a larger-than-life role makes their exit larger than life, too.

❖

Damn.

There are a few things I have learned in the past week.

The first thing being to revisit past events with caution; time can change your perception.

The second item being to importance for embracing the present and enjoying your company regardless of the entertainment or activity.

The third and most important thing is there is a difference between being prepared and over prepared and a difference between confidence and cockiness.

Being over prepared can tip the confidence scale to cocky in a fucking heartbeat.

To quote one of the greatest lyricists of our generation:

'Sit down, be humble.'

Intersection of Research and Reality.

There's a collision point in which your preparation and work meets the event of anticipation. Sometimes that preparation wasn't enough and sometimes it was.

The results will vary from gigantic feelings of every kind to an uncomfortable calm that reads as indifference or apathy.

But it's more than that.

The quiet is a reflection of dedication and commitment. An encapsulation of trust and understanding; an unremarkable silent moment speaks volumes. It drowns the anxiety and jealousy and amplifies love.

There isn't a zero-sum game or a perfect balance that bestows equality when ethical thoughtfulness exists.

An understanding of desire, need, and the ability to remain vulnerable is key.

Discussion and reflection yields love in abundance when paired in tandem with empathy and commitment.

This page is intentionally left blank.

This page is intentionally left blank.

The following pages contain entries written during the initial

2020 Covid-19 lockdown.

OPTIONAL INTERMISSION

Feel free to expose yourself at your own risk or enjoy the next few

PAGES 22-36

page turns of intermission.

This page is intentionally left blank.

This page is intentionally left blank.

Pandemic Papers

Processing social distancing and uncertainty in real time.

Don't forget to ~~exploit~~ thank your essential workers.

Positivity of Pandemic Proportions.

I don't know if ironic is the right word, but it's what I'm going with. It's amazing what six short months will do to your perspective and your feelings towards the spot you occupy in life.

A year ago, I felt like everything was going according to plan for everyone and I was sitting still, making all the right moves with no visible change. Now it feels like I've done a complete 180 where I'm feeling incredibly lucky for all the positivity going my way. Meanwhile it feels like the entire rest of the world has taken my spot and I'm feeling guilty about it.

Guilty that I've got a stable and successful job and millions don't. I've got health and the world is fighting a global pandemic. I am aware of my place in the structure of society, and I've benefited from it greatly.

I'm not exactly where I want to be yet, but I'm getting there. I want to help others get there too.

With all the negativity in the world right now, for once in my life I'm going to try to be the positive one.

Secondhand Chaos.

Take your time and truly feel your feelings.

Embrace your anxiety. Get to know your depression. Listen to your doubts, but don't trust them...only to be right in the worst ways.

The relentless comedy of errors that the longest 7 months of our lives has created isn't even that funny, but it makes you think. That's a good thing, right?

We think, therefore we are. We are alive.

We have rearranged our priorities ten times over and it is only Tuesday.

We heard about the incident. We heard that too. We felt that.

We are living secondhand chaos in the most hands-on ways imaginable only in our dreams. Technically nightmares are dreams, but unfortunately this dream is all too real.

I'm hoping for a day that hindsight is anything but 2020.

Dashboard Cookie.

Wrapped in see through manufactured plastic.

You can see every piece but can't touch it until...

It sits on the dashboard as a prize for finishing a meal, slowly warming itself in the sun while it waits for its barrier to be broken, signaling the end...

Dashboard cookie is silent. Dashboard cookie knows it's spot in the world.

Dashboard cookie knows there will be an end but doesn't know when, but it knows how.

There's a normalcy that doesn't feel normal and it is difficult to articulate what it feels like. Inside the barrier, the dashboard dirt doesn't taint the cookie, nothing changes until the guard is torn through.

You are dashboard cookie. So am I. We all are.

Good Riddance.

What can I do for the fires in Australia? Why did I become swallowed by a heart wrenching feeling of despair when Mamba passed away? Murder Hornets sounds fake as fuck.

We put in an offer on a home we fell in love with. It was not accepted. We found another quaint house on the wrong side of town that our offer was rejected as well. Little did we know we'd find a solar powered diamond in the rough off a street we've traveled hundreds of times in a town I had mixed memories about as a kid.

Regis and Sean, cultural icons, passing wasn't even the worst part. The shortened baseball season and deprivation of a March Madness doesn't even seem that bad looking back 4 years in the span of 366. That's not a typo, it's a leap year we anticipated the Olympics bringing the nation together. Instead, we have become an increasingly divided country in terms of health, social, and political views, where the Venn diagram's overlap is few and far between. Loved ones in the form of small businesses, restaurants, pets, and people have withered away to nothing but a memory. We've all gained the COVID-19 and let me be the first to screw 2020 hindsight.

I can't wait for the day I can visit people and places without worry. The first show I get to see where I don't have to login to a virtual screening is going to be incredible. I think. it's time to turn over the calendar page and burn last year to the ground. Keep surviving and stay positive.

Universal for $600:
'Presently the most hated number in the world.'
What is 2020, Alex?

NSFW

The following pages contain explicit imagery not suitable for those who are children and/or easily uncomfortable with sex, clowns, or a portrayal of the holy trinity with a famous mouse and fast food mascot.

Viewer Discretion is Advised

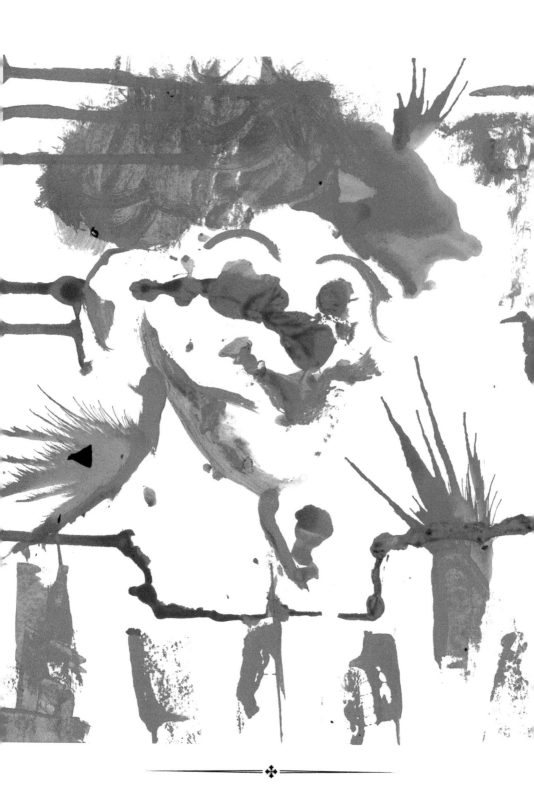

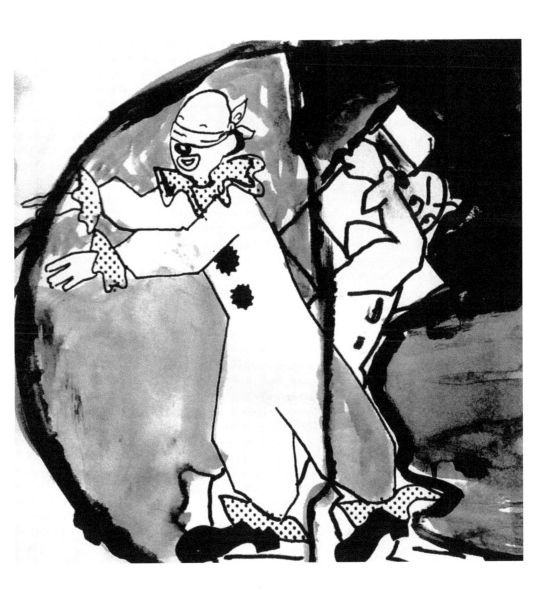

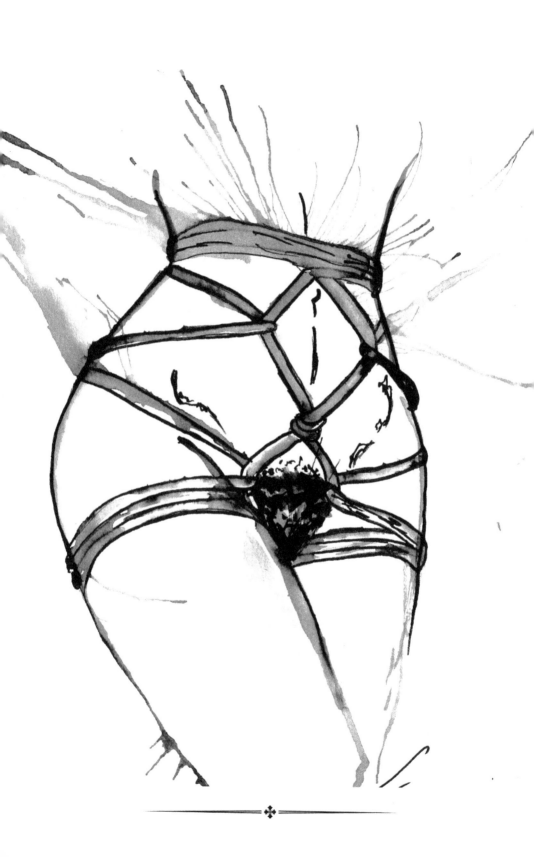

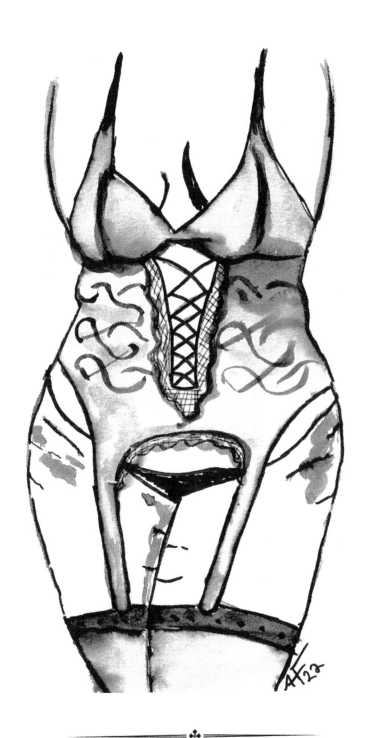

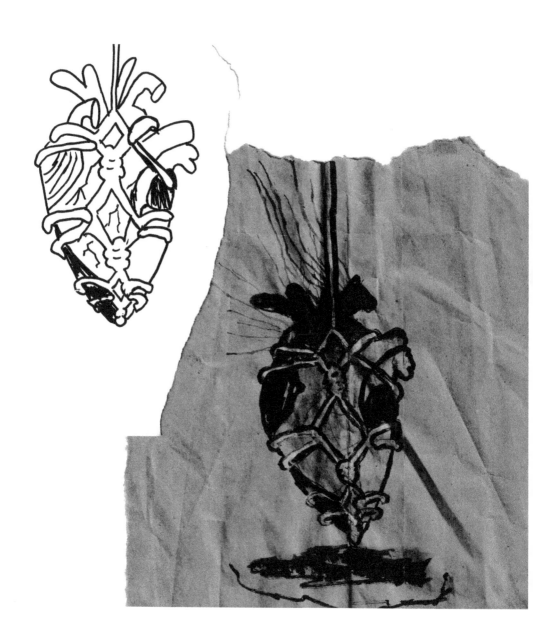

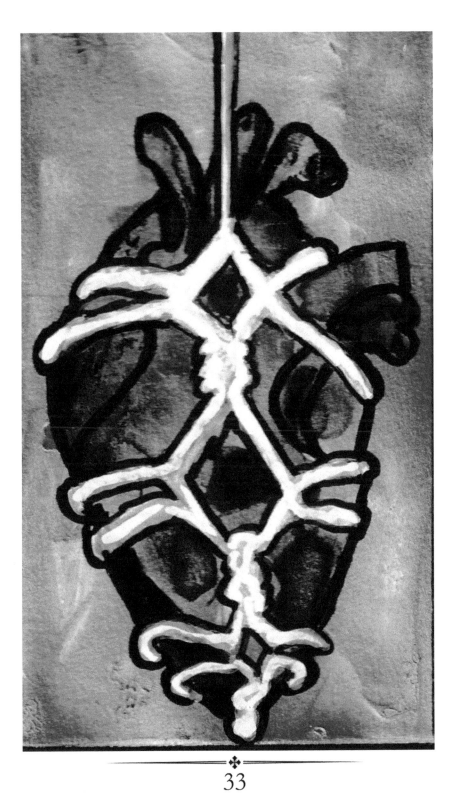

Act II : Images

Act II : Images

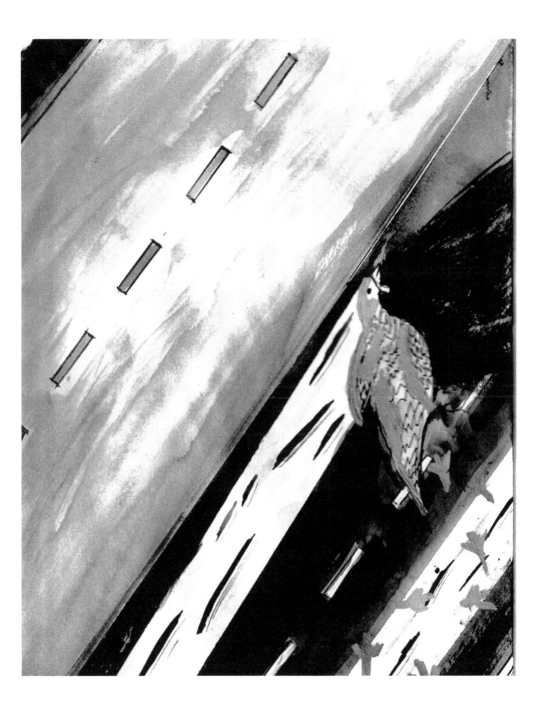

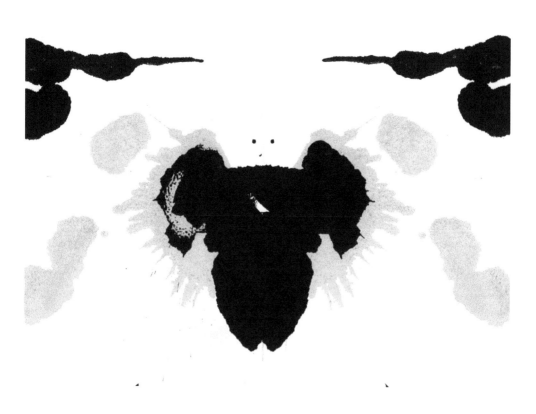

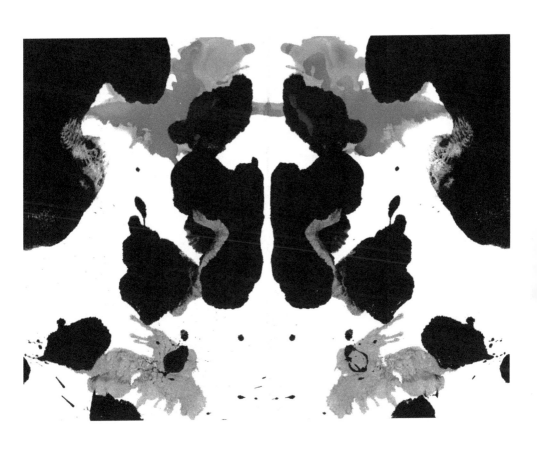

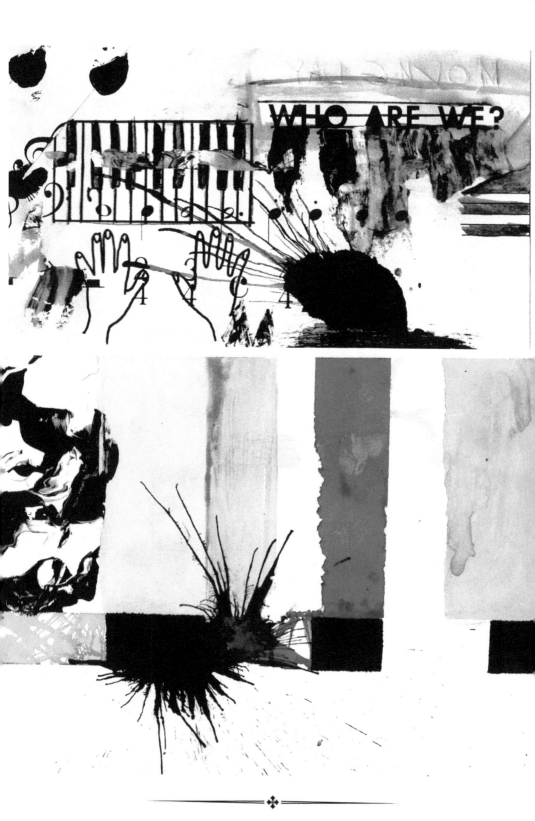

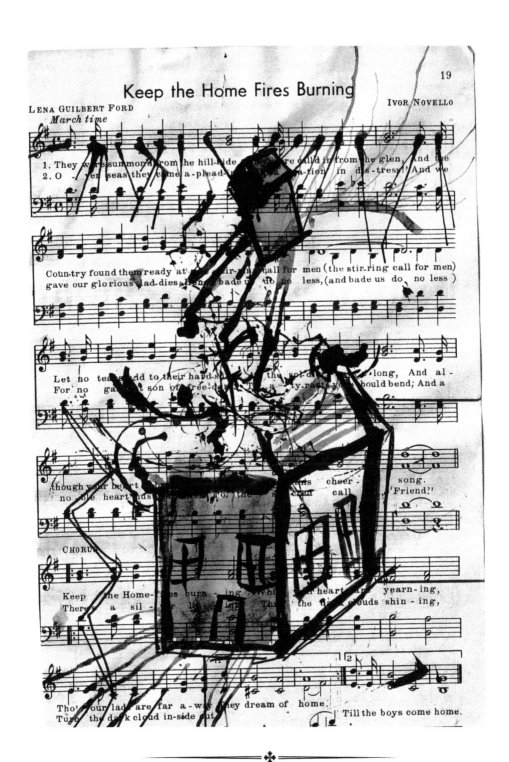

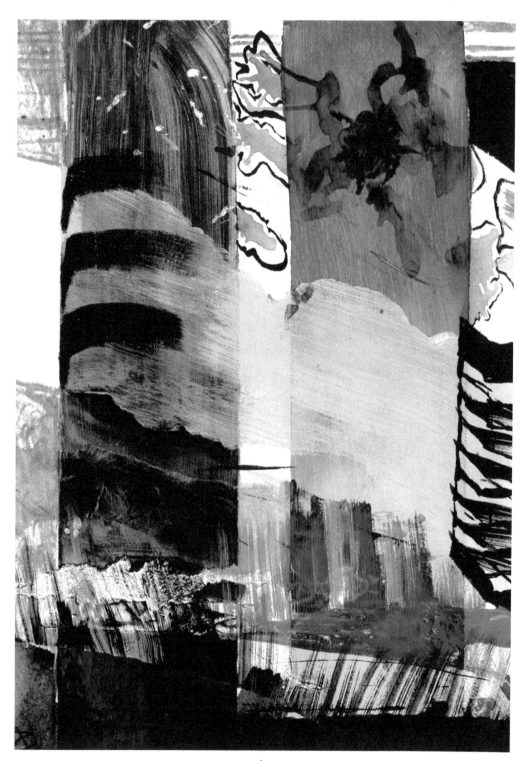

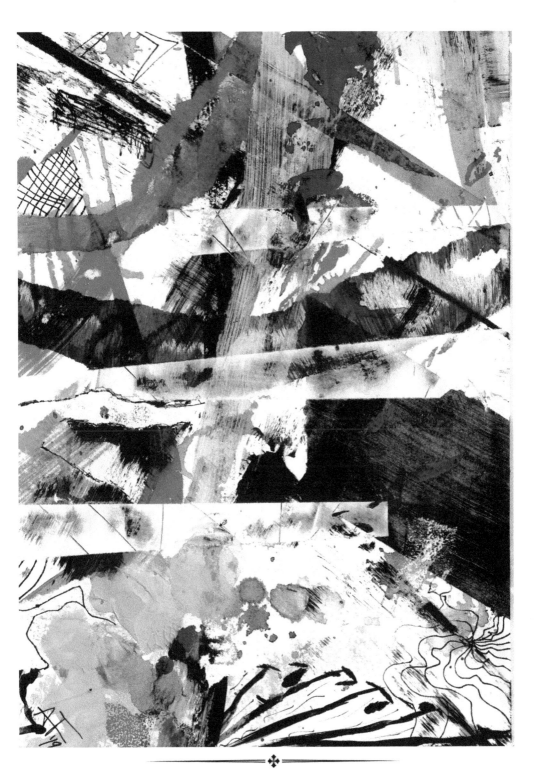

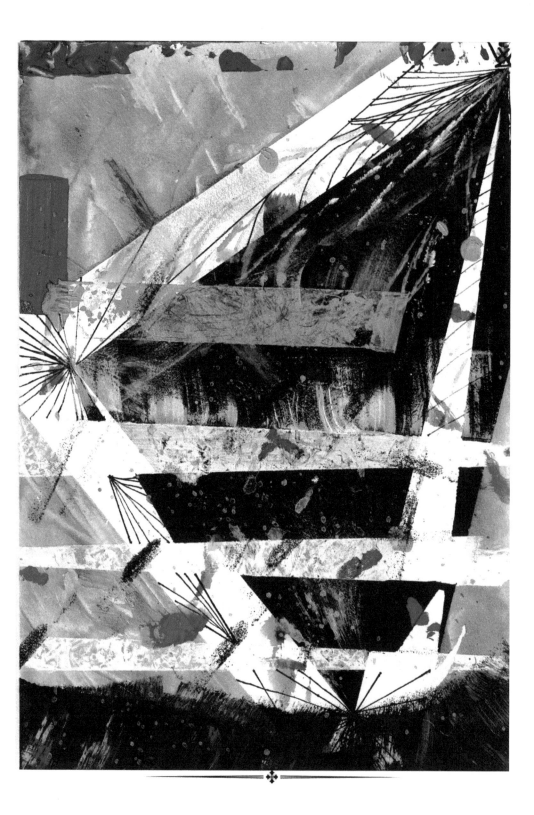

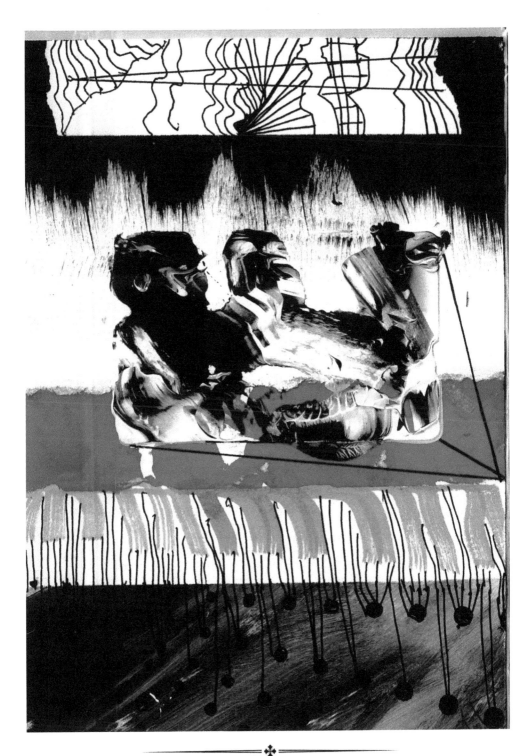

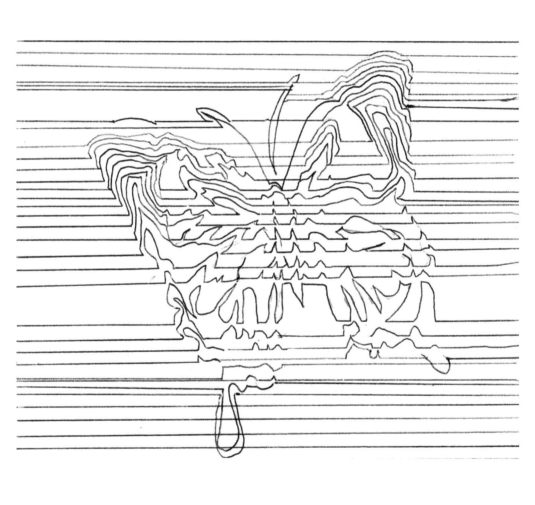

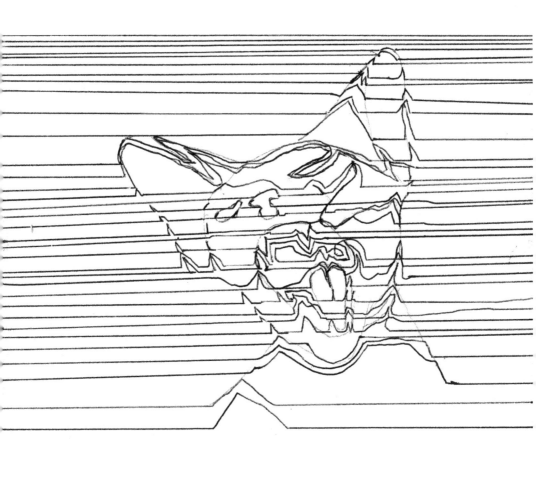

Act III :
Accepting AF

Act III :
Accepting AF

My Reason for Existence.

Art is subjective. Goals are objective. Combine the two and you get Raison D'être.

Raison D'être - |ˌrā-ˌzōⁿ-ˈde-trə| *Noun* : the most important reason or purpose for someone or something's existence. A reason for existence.

I've had a dream for quite a while to have my art shown in a gallery or museum other than the cafeteria of a high school but didn't know where to start.
I never expected that gallery or museum to be the Wichita Art Museum in the same building I've seen Rockwell's and Warhol's.
Whatever positive energy has been thrown my way, thank you for allowing me to get my Foot in the Door.

The Foot in the Door gallery ran from 10/10/2020-04/18/2021 at the Wichita Art Museum showcasing local Wichita artists with the only rule being the piece had to be 12 inches by 12 inches.

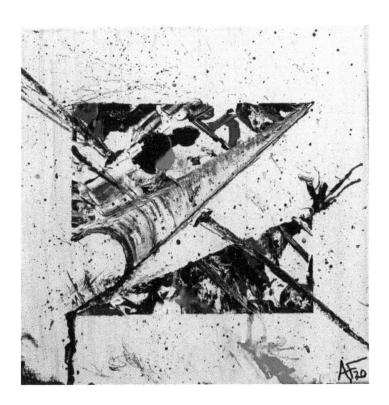

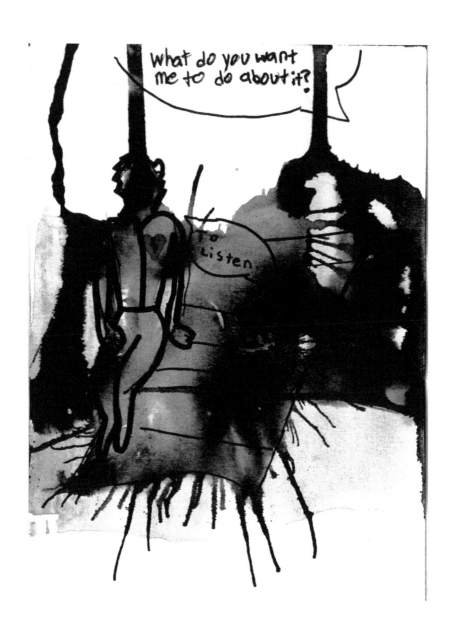

Dark Side of the Moon.

As the night continued to creep, an energy I've never experienced illuminated my space, everything slowed down and became disorientating and clear.

Contradicting emotion and reflection flooded my thought vessel that guided me home. where I could embrace hysteria in the comfort of my safe place.

Screams of inquiry to nothing but the humid air and still ambiance.

Alone and hurt worse than death.

Heartbreak and searching for the reason.

Mulling through the words and experience, trying to determine what it was I did to deserve my current state.

As I reluctantly struck the headboard and dug my unclipped nails into my arm to provide a sense of grounding, I discovered I could not blame myself for how I was feeling. The realization sent me into orbit.

I did not have the ability to hold myself accountable in this instance. Because I was not at fault.

What a concept.

Brace for Impact.

The schematics of that concept are not something I have ever concluded in my past experiences.

Whether valid or not, I have always been able to manipulate my brain into owning the errors of others.

Hurling myself past the gravitational pull of logical reasoning.

Declarations of regret were discussed, and a list of grievances was given.

The desire to forgive was present but unable to be relinquished upon the descent of the morning.

In time, in tandem with space, I feel pardon will be bestowed but for now a piece of my heart will remember the pain.

Until agency is owned, and accountability is practiced, that meteoric piece of my time keeper remains ill-equipped to fit back in the only space it has ever known.

Until then, I will spend the next lunar cycle being cautiously optimistic for the next voyage and bracing for reentry.

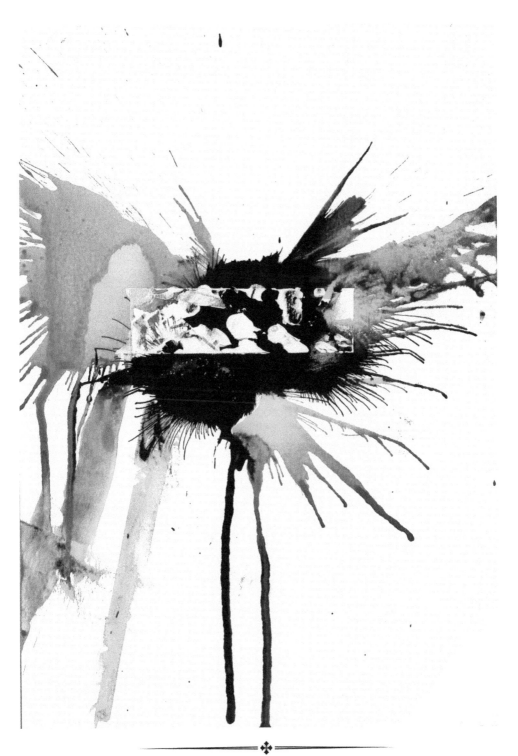

Contradiction of Indifference.

As someone who finds themselves attempting to be the 'bridge' for others, handling being sad or upset or angry has felt completely different as I imagined.

The bridge of conversation, the bridge for happiness, the bridge for productivity, the bridge of caring. I do realize it's a self-created position I have put myself in but it doesn't negate how I am feeling.

I have been constantly at odds with how I am handling the grieving process. While most everyone visually was upset during the funeral, I found myself at relative composure given the circumstances.

For myself, I needed to internalize and make sure everyone else was alright. I immediately became fearful that those around me would question why I wasn't crying. What they didn't see were the stacks of unsorted Baseball cards that normally would bring me joy to put in their place and the months' worth of laundry that had compiled because I couldn't sort through the outfits I wore the last time I saw grandad on x/y/z days.

I understand everyone handles the process differently. But I somehow feel like I'm doing it wrong.

Why is it that when requested to do an honorable thing such as perform taps at a grave site for my role model that I felt I was doing something incorrect?

Why is it that I'm mad at myself for not 'being sadder' the day of the funeral?

I guess time will answer my thoughts, but can it please hurry up?

Bingo Bango Bongo.

Like a golf ball in a cup, he simply disappeared and I was left searching.
My mind racing with so many memories I stayed up another 5 hours and slept for 4.

It was an awkward feeling I immediately possessed, it wasn't a feeling of sadness I once imagined but a feeling of content, a feeling of, pardon the cliché, relief.

He went out not with a flash but a fade, but what I didn't understand until just moments ago, is that a fade is easier to handle. It isn't abrupt, it gives you time.

Time to process.

Time to grieve.

Time to say goodbye.

Maybe some only needed to say goodbye once. Others said it more often, but all were equally important.

As of current I'm left with one thing...

The observed advice I received when golfing: if you prepare yourself physically, you will be okay, if you prepare yourself mentally, you will be good, but if you are able to combine physical and mental preparation you will be great.

Maintaining physical strength is incredibly important but if you don't have the mental strength and patience to handle to good times and the bad, you won't make it much past the first dog leg right.

Infinite.

As I still am processing last year, this year is already an uphill fight for positivity. It must be that time in adulthood where many loved ones start going to the other side and we are left saying see you soon. As I felt some sort of normalcy, another important figure went home.

51 weeks apart from their other half.

The human species' ability to feel love and love someone so deeply that a person can literally become ill without their other is morbidly incredible. I said after the service "we'll see you soon..."

51 weeks later and I'll have to wait longer.

But we will. We will see you again but not soon enough.

The mixing of two losses within a handful months separated but 'the' holidays, piling onto one creative individual, results in run-on sentences about love, life, and grief.

Colors don't seem as bright right now, but that's probably from the residual tears left in my eyes. The music doesn't seem as clear right now, but that's probably from your voice still whispering in my head.

My motivation, my ability to feel happy or sad, my energy all seems to be wishy washy, but that's because my heart is still healing the part of it they took at departure.

The cold seems colder without your laughter slicing through the wind, but I've got my hat and gloves on like you always advised.

I love you and I miss you and I can't stop thinking about you, of course you probably already know that.

❖

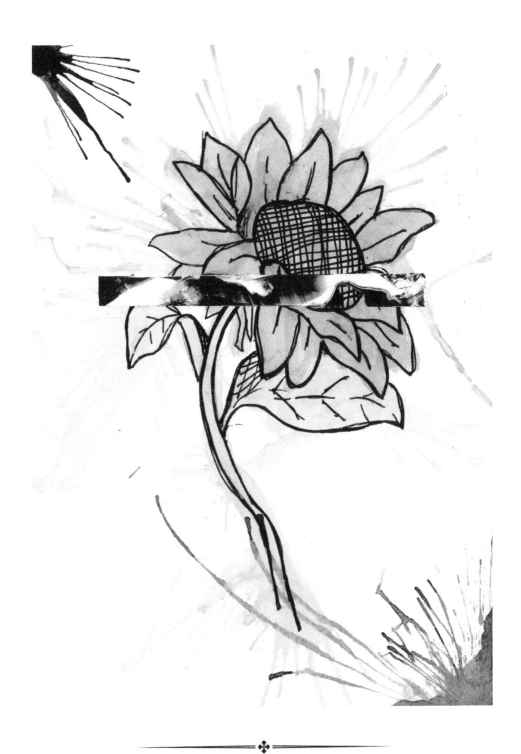

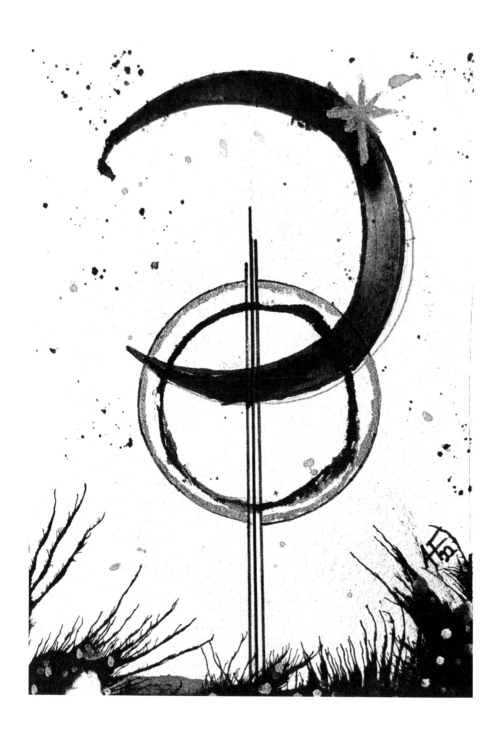

Interstellar Companionship.

What a sensational feat it is for the sun and moon and stars to coexist.

How wondrously dynamic the companionship between night and day continues to revolve around the globe in harmony.

The moon thrives under the gravitational pull it shares with the sun, as it always has. In tandem to share the lightest lights and the darkest darks of space. Forever married to one another since the beginning of time itself.

It's no coincidence that the stars have been quietly surrounding the earth. The moon. The warm glow of celestial energy provides support to the moon in its darkest hours. Giving it enough light to believe it's valued just as much as any other object in the universe.

Bright, shining qualities of the sun has and always will be the moon's infinity. It is only recently that the moon truly feels the presence of the stars surrounding it and knows now life would be incomplete without them.

The Moon and The Stars. The Moon and The Sun.

Forever an interstellar companionship complex and interconnected as space and time.

Imitating Fragments of Nostalgia

If you are reading this, something spoke to you on such a deep level that you needed to possess a piece of me. Maybe it was the blackened frame, that was originally a wedding gift that my spouse and I have opted not to keep but still holds fond memories. Perhaps it was the backing painted in a slightly lighter black than #000000, which was the last bit of left over paint used to revitalize my first home's exterior. Is that what drew you into this surrealist work?

The devil is in the details and even though art is subjective, the use of items from my past to create something new and pay tribute to those before me is what made the price tag so steep for what one of my [REDACTED] called "weird and disturbing. A little lazy and uncreative".

The metal holding the note paper roll was taken from my grandad's wedding tuxedo hanger that secured his trousers on the garment vessel. The paper was thrown in a box of items I took from my previous job, where I was [REDACTED] with no explanation as I just finished a year and a half long project that I poured countless hours of thought into and all that was received was a half sincere "I'm Sorry". The twine was left in my late grandmother's sewing box that camouflaged itself as a cookie tin and the pen was left in my desk of my new place of work that felt appropriate to include in this nostalgia capsule to complete the full circle of my career history to this point.

Lastly, there is the red crustacean that sits on an outdated form of communication, which as you might have guessed has a deep connection to me as well but that is for me to know and you to ponder.

Thank you for supporting art. Thank you for fulfilling a dream. Thank you for surviving this long. Thank you for reading.

Until next time~

AF

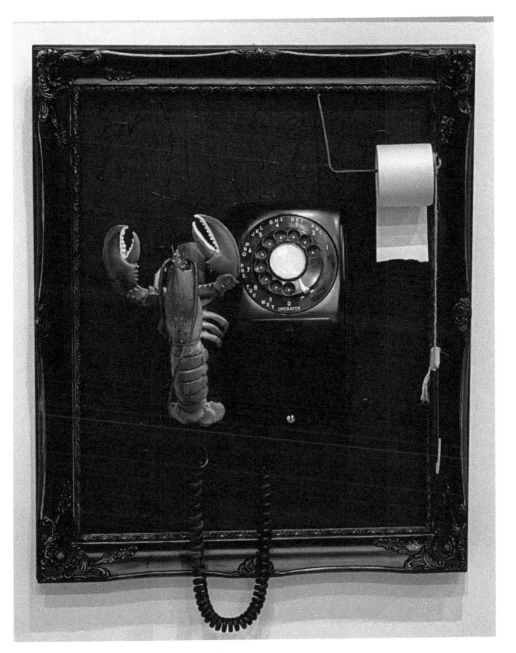

"Those who do not want

to imitate anything,

produce nothing."

- Salvador Dali

XXX.

What is fear but a tangible emotion that shines a searchlight on uncertainty?

Three years and a few days removed from what I considered a milestone.

I am happy.

Happy with the silence I can sit in to reflect.

Happy in the consistency I once felt was boring.

Happy with who I am as a person in the body I hated for so long with a brain that did everything but push me to a definitive finality.

My perspective has changed as well as the leading digit in my age. I would love to say at 12:01 am on July 12th, 2021, everything changed due to my survival of my 27th year, but I would be lying.

Truth be honest, the handful of months leading up 2022 was hellish in my psyche.

But here I am, truly and without sarcasm, living my best life. Feeling the most me I have ever felt and owning my accomplishments.

The hardest place for me to be is the present.

The past is easy to get infatuated with and tomorrow is just your future yesterday.

I have worked my hand to the bone to recognize my patterns of apathy and be intentional with everything I do from sticking to my personal boundaries to giving my body and mind the proper space to rest and feel.

After the journaling and the therapy and the medication and not necessarily learning all my why's but embracing my truths has led me here.

All of that has led me to right now.

❖

And the hardest part of my journey so far wasn't being diagnosed with depression and anxiety. It wasn't even fully processing that my fear of dying at 27 was a wish my brain bestowed upon me.

The hardest part of it all was three elementary words:

I need help.
I need help.
I need help.
I need help.

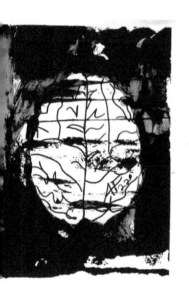
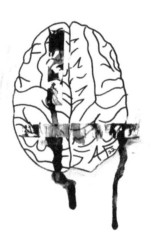
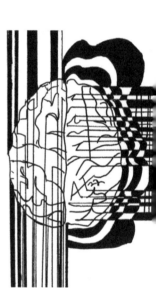

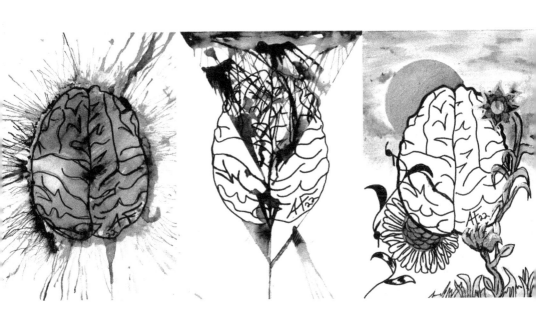

EPILOGUE.

For as long as I can remember I have felt at odds with the zeitgeist of what it means to be. To be human, to be accepted, to be worthy. I've been drawn to people and images and places that are hard to put into words and categories. I am attracted to the gravitational pull of the uncharted and indescribable. Finally, after 30 years, I can admit to myself I am not normal. I am abstract.

The following pages are excerpts from my personal journal I feel are important to share. While my journal entries cover a deeply difficult period in my life, I allowed myself the time and space to journey through therapy to assist in self-discovery and mental stability. I believe there are things I wrote down that other's might think and not realize that what they are feeling is relatable.

The contradiction of feeling so isolated in your mental health and place in the world while being surrounded by others that feel the same way is an equation that becomes clearer as more individuals talk about their experiences with mental illness.

Lastly, before I include some journal entries, I want to mention that journaling and being intentional about being present has been life changing for me. I encourage you to take some time and reflect on your day, your week, your current.

Excerpts from 1/22 to 7/23

-First therapy appointment. I think it went well. I created a list of goals: do I have anxiety or depression or adhd or all three? 8-12 month plan to address all my goals. I am open to meds, maybe. I am worried about my sex drive and feeling numb to the world. Work was meh. Therapy schedule concerns me with work. Will have to work with staff on helping me. REDACTED job rejection.

-I feel like things are aligning in the right direction. Maintain expectations, cautiously optimistic. Baby steps, trust my gut.

-Phone screening with REDACTED went very well. 2 possible opportunities. I also interviewed with REDACTED. It went good. Trying to manage my expectations, but it feels positive. I cried a few times at work. I can't maintain how I am feeling if I stay. The morning was awful but I ended the day on a smile.

-I am feeling very ungrounded and things, everything feels like it is floating away. Work environment has me feeling more and more unwelcome every day. I am scared for the future. Am I making the right choices for me? Who am I? What am I?

-I am down. I am hopeful, I am cautiously optimistic. I know what I am doing. I am alive. I am loved. I am supported. I am smart and creative and compassionate and understanding and a great fucking REDACTED...

I am feeling unwanted, uncertain, unstable, anxious, squiggly, achy, I am feeling this is temporary.

Rejected for all three roles.

FUCK.

-Friday was painful. I felt humiliated. I feel stuck and inadequate. I feel unwelcome at work, at job opportunities, at home, unwelcome by my friends and family.

I felt like a burden. I feel like I am stuck; overqualified for entry level, underqualified for the next step...I cried so much today and then I cried some more. I am embarrassed and resenting telling my friends and family because I am afraid of following up with them. I am a broken record right now and I want to change my tune.

It can get worse but there is a stronger possibility it gets better.

<center>✤</center>

-I am excited for me: my growth, my personal journey to feel like I fit in and feel comfortable expressing me. I will be starting Wellbutrin this week and I am weirdly excited for it.

I want better days. I am hopeful, but I am fucking scared.

-It's only been 3 days on Wellbutrin, but I feel like I am noticing some positives. I am gathering all the anxiety and I can push things to my peripherals to focus on one thing at a time. I still see everything but it isn't as intimidating.

-REDACTED said a lot of people don't tell you healing and bettering yourself is going to hurt...

A LOT.

But it is a slow move to being more you. It is going to stir up a lot of shit. You are going to question your worth and if it is all worth it. I told her I felt that on a spiritual level and I want to stop feeling like I am "TRYING". Trying to be me, trying to get a new job, trying to be happy in my relationships and life. She said trying is okay. You will start doing when you least expect it.

And I believe that.

-I am incredibly stressed with work, BUT I am not feeling a crippling overwhelmed meltdown anymore. I am going to give some credit to the meds but a lot of credit to myself and how I am trying to cope and process things individually vs. everything all at once.

Trying to stay positive. Finding new music for the first time in months.

-I put in about 40 applications over the past 2 weeks. I need to give myself a break but I am worried I may miss out.

-This week is the first week in a long time I don't feel broken. Manage expectations. Hope for the world.

I haven't needed or remembered to journal lately. For about a month. I feel more present, more happy, less anxious in general. I think I am going to even say stable.
Overall feeling happy.

-I graduated therapy today. I am proud of myself.

❖

-I got fired from REDACTED today. I have a lot of people in my corner. Things with REDACTED feel promising. Today has been weirdly relieving and also the most confusing day I have ever experienced.

FUUUUUUUUUUUUUUUUUUUUUUUUUUUUUCCCCCCCCC
CCCCCCCKKKKKKKKKKKKKKKKK

-The last day of June has me feeling an entire spectrum of emotions I am not used to feeling or embracing. The confusing balance of relief and anxiety/anger and happiness still does not compute.

I am frustrated with the lack of feedback I was provided. It takes a few misguided and closed-minded people to turn an environment toxic.

I have a support system stronger and larger than I expected. (12 names) were immediately in my corner. They carried my anger and frustration while providing hope.

I've never understood hope. I understand it now.

-It's funny how often they talked about getting robbed. I certainly was. Robbed of dignity, peace of mind, and confidence.

It's funny how it all played out, I could see it coming in slow motion for 6 months.

The inevitable ran parallel with my personal growth, almost in lock step and in tandem.

As my brain and I got more on the same page, my environments became more glaringly unfit.

How many things did I do or tolerate because my brain was so quick to pull the trigger on myself.

Never again.

I know the phrase rose colored glasses is typically a bad thing, but I feel like I've got mine on for the first time and life isn't so bad.

Fast forwarding a year to my final two entries of my 20s, a day before my 30th birthday.

-1 year to the date I accepted my new role. The 29th year of my life has been a year of ~now~. I was consistently happy and present. I felt supported. I felt like I fit into the world. My mean brain wouldn't visit as often. I am proud of myself. It feels like life is more cohesive.

I feel more real than ever before. I REDACTED to most everyone I know. I am flexing my creative muscles daily. I am exploring REDACTED and learning. Happy final day of my 20s.

For the first time ever I want to live.

-Dear Alex from the past.
You are a strange kid, but don't stop. You have odd friends now, they are great.

That feeling of being able to have REDACTED is valid. It's okay if everyone involved knows. You have so much love and empathy for others. That doesn't make you gay or stupid or manipulative.

Remember when you said you would never get a tattoo? You have 7 now, they all mean something to you.

Keep your interest in drums, I got us a kit recently. We are not great at it but it's fun.

We get to go to so many concerts.

There isn't anything wrong with you, our brain just needs some help with it's chemicals.

❖

It's okay to cry. It's okay to ask for help. You are actually stronger with the assistance of others.

Remember when you got an art set for our 12th birthday but you didn't use it because you weren't given much feedback or encouragement for it? Keep that drive for art alive, we do so much art. People like it.

You raise money for suicide awareness with your art.

Your last shared birthday with grandad comes quicker than we imagined.

I am sorry life is hard. But don't end it, you can't, and don't, because I am writing this.

I am so proud of you.

Liner Notes from Alex:

The reason I've decided to label this page liner notes is due to how often I would read my CDs and Records and hope to find my name somewhere hidden in the liner... even though I didn't know any musicians personally. Additionally, I must to pay tribute to the biggest reason I am here today; music. Without bands like Aerosmith and Jukebox the Ghost or artists like Donald Glover and Jack White, I would not be alive, let alone any resemblance to the creative person I am now. I would like to take this opportunity to thank as many people that come to mind. I apologize in advance if I forget anyone. First I want to thank Kaitlyn. You are the sun to my moon. I love you. Thank you to Mrs. Terhune and Mrs. Smith. Mr. Huss, Mr. Howe, Mrs. Perkins, Mrs. Teresa Miller, Mrs. Chacey. A giant thank you to Condog for always being here as a creative supporter, a friend, and most importantly my brother. TF, Chris Chris, Ali, Cory, the Ewers, Courtney, Brent, Annie aka Rainstonevisuals, Jerry, Celeste, Diane, L, Megs, the Davis', the Millers, Longhofer, Lindsay, Mariah, Jessica, Ben, Kacy, Trevor, Jed, Derek, Shaila, Lance, Jenni, Lynne, Elisabeth, Kirsten, Evan, 6M. I love you Mom. I love you Dad. Several works were in memoriam to Grandad and Aunt Dorothy. Both heavily influenced my creativity, I love you and miss you both dearly. To Grandma and Grandpa, I love you more than the moon and the stars and the sun. Creative influences include Weird Al, Salvador Dali, Banksy, Norman Rockwell, Bob Ross, Hobo Johnson, K. Flay, Rob Zombie, Shel Silverstein, Bo Burnham, Mitch Hedberg, Mike Birbiglia, Pete Holmes, Wes Anderson, Brian Frange, Tommy Seigel, Dan Cummins. & lastly thank YOU. Who ever is reading this, thank you for letting me be a small part of your life. I'm grateful to have the resources & opportunity to pursue my passion. I am the most me I have ever felt and I owe a lot of it to you.

Until Next Time,

AF

ABOUT THE AUTHOR

Alex Freund is a midwest creative that grew up in Mulvane, KS and went to college at Wichita State University, where he received a BSA in Psychology.

His art has been included at Mark Arts and the Wichita Art Museum. His creative projects online have cultivated a diverse audience in the thousands that is as eclectic as his works are. Ranging in mediums from podcasting and music to visual and written communication.

Freund is married to childhood crush and high school sweetheart, Kaitlyn. Together they have two cats, Holly and Ozzie. The couple owns a home in the Wichita metro.

If you are reading this, I want you to know how uncomfortable it is to write my own biography. It's just weird. Anyhow.

Thank you so much for reading any of my words.

Until Next Time,

See ya.

AbstractAF.net - @Freundlydude - Abstract.AF.Gallery@Gmail.com